Emily Carr

Terry Barber

MAPLE LEAF
SERIES

Emily Carr is published by
Grass Roots Press, a division of Literacy Services of Canada Ltd.

PHONE 1–888–303–3213
WEBSITE www.grassrootsbooks.net

ACKNOWLEDGMENTS

We acknowledge the financial support of the Government of Canada through the Canada Book Fund (CBF) for our publishing activities.

Produced with the assistance of the Government of Alberta, Alberta Multimedia Development Fund.

**Government
of Alberta ■**

Editor: Dr. Pat Campbell
Image research: Dr. Pat Campbell
Book design: Lara Minja

Library and Archives Canada Cataloguing in Publication

Barber, Terry, date
 Emily Carr / Terry Barber.

(Maple leaf series)
ISBN 978–1–926583–41–9

 1. Carr, Emily, 1871–1945. 2. Painters—Canada—Biography.
3. Readers for new literates. I. Title. II. Series: Barber, Terry, 1950– . Maple leaf series.

PE1126.N43B36325 2011 428.6'2 C2011–904442–0

Printed in Canada

Contents

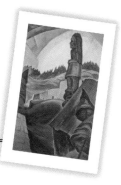

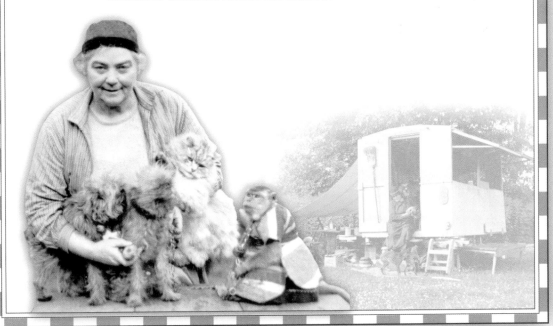

A woman bids for a painting.

The Wind in the Tree Tops

The people sit in a room. The people love art. They **bid** on pieces of art. They bid on a painting. The painting sells for over two million dollars. The artist is Emily Carr.

The painting is called *The Wind in the Tree Tops*.

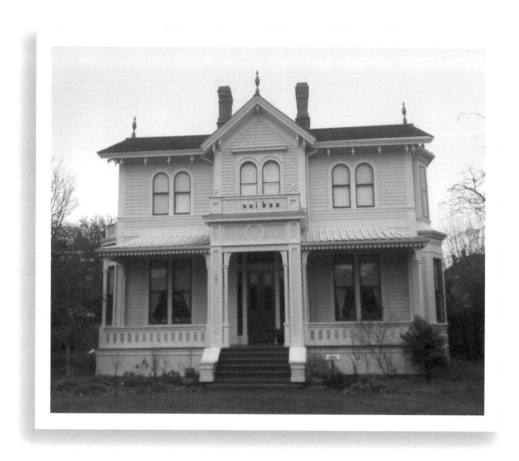

The Carr family home.

Early Years

Emily is born in 1871. Emily has
four older sisters. She has a younger
brother. Her parents own a nice home.
Her parents are strict. They teach
Emily manners. Emily cares little for
manners. Emily is stubborn.

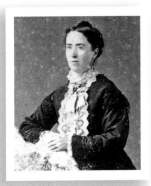

Emily's mother.

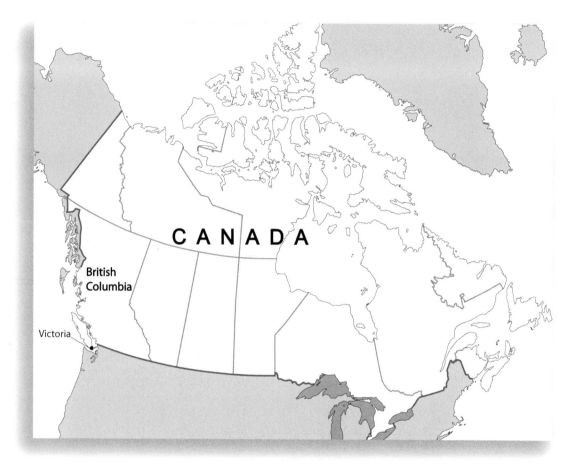

In 1870, Victoria's population is 4,200.

Early Years

Emily's family lives in Victoria. Nature is close by. Emily loves to run in the fields near her home. As a child, Emily loves two things. She loves animals. She loves the outdoors. Emily is a free spirit.

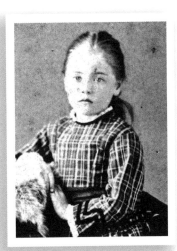

Emily, age five.

Emily draws her dog.

Early Years

Emily is eight years old. She wants to draw her dog. She uses a burnt stick for a pencil. She uses a brown bag for paper. Her father and sisters like the drawing. Emily always makes due with what she has.

Emily's father lets Emily take art lessons.

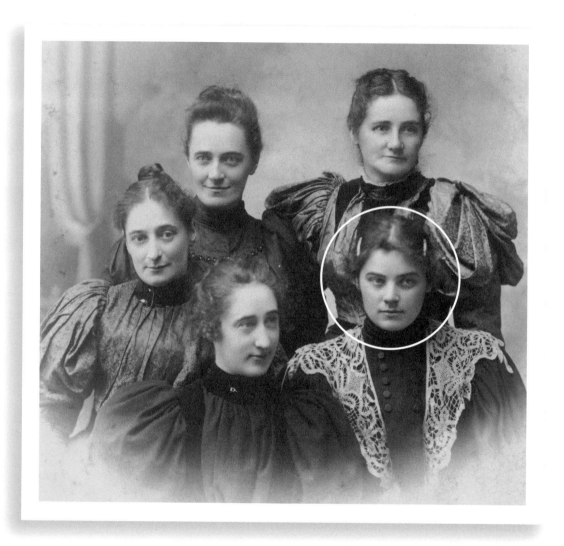

Emily and her sisters.

Early Years

Emily's parents die when she is in her teens. Emily's older sisters look after her. Emily's sisters are stricter than her parents. Emily wants to get away from her sisters. She wants to study art. Emily goes to art school for three years.

Emily studies art in San Francisco from 1890 to 1893.

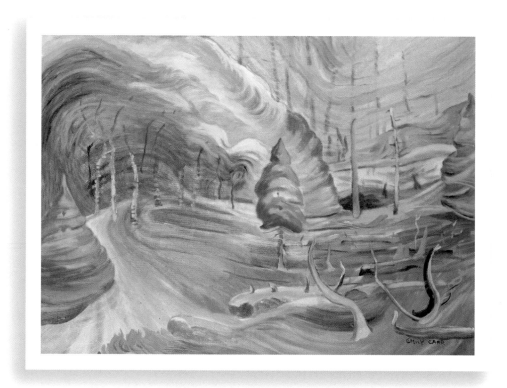

One of Emily's paintings.

Emily's Passions

Emily returns to Victoria. Emily's art reflects her passions. She loves to paint animals. She loves to paint nature. Emily paints trees. She paints big skies. She tries to make her paintings look real.

Emily likes to paint with watercolours.

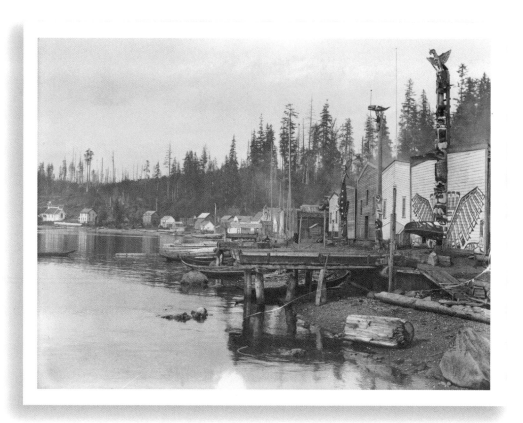

Totems in a First Nations Village.
(Alert Bay, 1890s)

Emily's Passions

In 1898, Emily takes a short trip. She visits a First Nations village. She wants to learn about First Nations culture. The people like Emily. They give her a nickname. They call her Klee Wyck. This nickname means Laughing One.

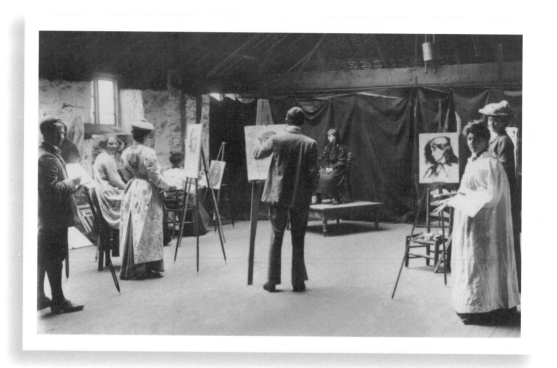

Emily goes to art school in England
from 1899 to 1904.

Emily's Passions

Emily saves her money. She studies art in England and France. Some French artists paint with bold colours. These artists are called the "wild beasts." Emily learns how to paint like the French artists. She starts to paint with bold strokes of colours.

Emily studies art in France from 1910 to 1911.

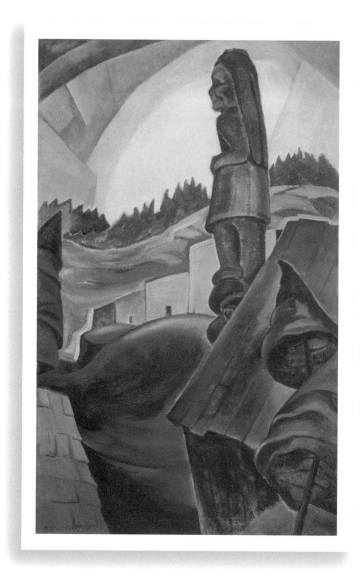

One of Emily's totem paintings.

Emily's Passions

Emily returns to Canada. Emily sees the world in a new way. Emily paints as she *sees*. Emily paints as she *feels*. Sometimes, she paints the skies yellow. Sometimes, she paints the water red. Emily has found her style. Her paintings are **unique**.

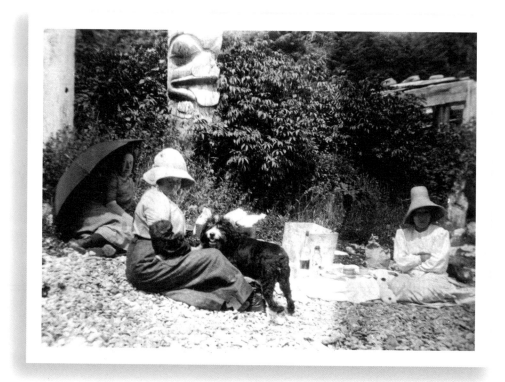

Emily has a picnic in a First Nations village.

Emily's Vow

In 1912, Emily goes on a 6-week trip. She visits First Nations villages. She knows their way of life is in danger. This trip plants a seed in Emily's mind. Emily **vows** to use her art to record their way of life.

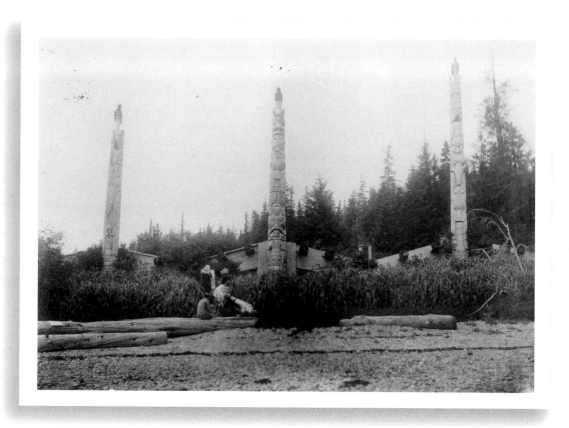

Emily paints totems on a beach.

Emily's Vow

Emily is afraid the totem poles will **vanish**. She says: "The **Indians** do not make them now. They will soon be a thing of the past." Emily paints many totem poles. Emily's totems are alive. Her totem birds look as if they might fly away.

Emily also paints First Nations villages and people.

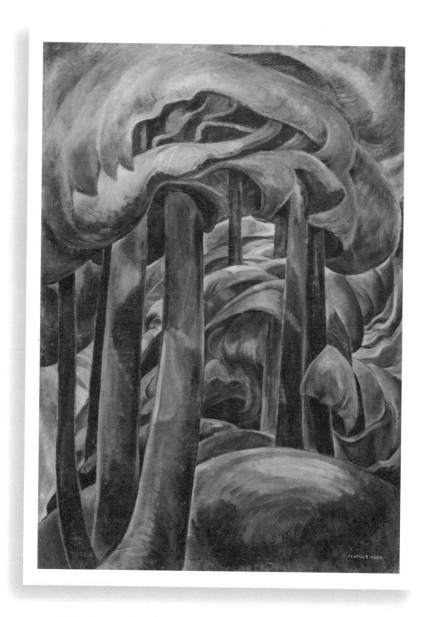

Emily calls this painting *Western Forest*.

Emily's Struggles

To make a living from art is hard. To make a living as a Western Canadian artist is harder still. To make a living as a woman artist is impossible. Many people do not like Emily's bold new style. Many people are shocked by Emily's paintings.

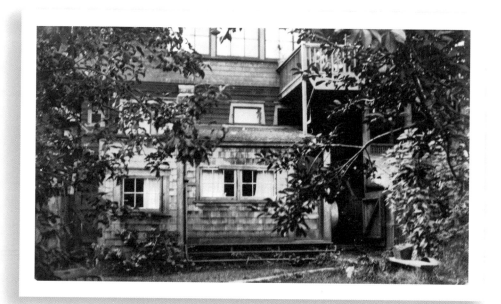

Emily builds her home in 1913.

Emily's Struggles

Emily cannot make a living from her art. Emily's father has left her some land. Emily builds a house. Emily is now a landlady. She rents out rooms in the house. She makes a living as a landlady. Money is tight.

Emily is a landlady from 1913 to 1927.

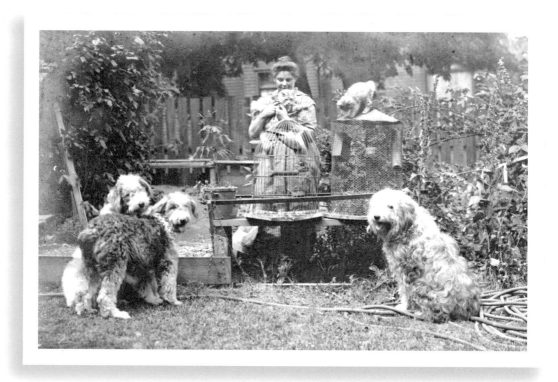

Emily and some of her pets.

Emily's Struggles

To make extra money, Emily breeds
dogs. She sells the pups. Emily does
not sell all her dogs. She keeps many
as pets. Emily does not want to marry.
She can make a living on her own.
Hard work never scares Emily.

Emily also
makes and
sells pottery.

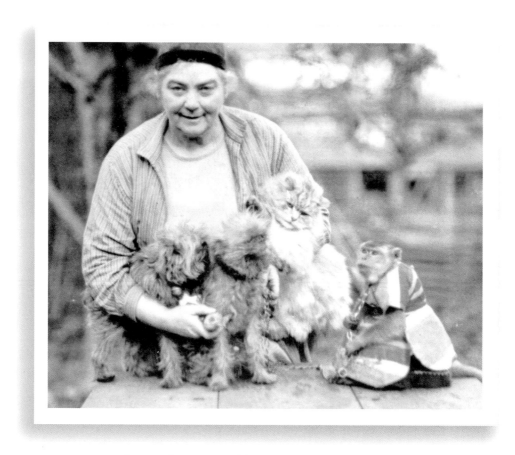

Emily and some of her pets, including Woo.

Emily's Pets

Emily loves all animals. Emily has
cats. Emily has a parrot. Emily even
keeps rats. One of her favourite pets is
a monkey. The monkey's name is Woo.

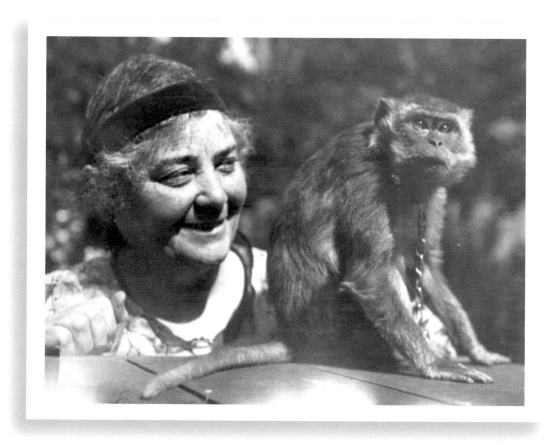

Emily with her monkey, Woo.

Emily's Pets

Woo goes everywhere with Emily. Woo goes with Emily on trips into the forest. Emily takes Woo on walks with her other pets. People see Emily with her pets. Some people think Emily is odd. Emily does not care.

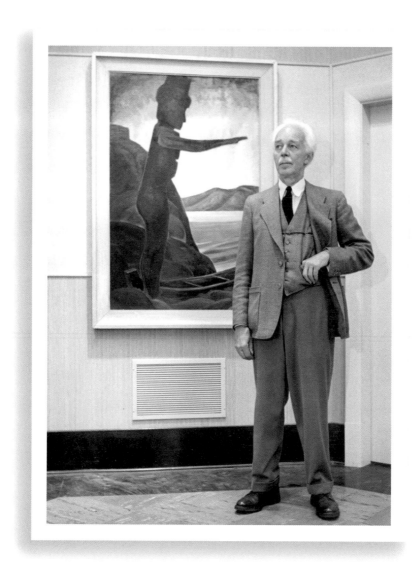

Lawren Harris stands in front of
an Emily Carr painting.

Emily's Mentor

For 15 years, Emily works hard to
survive. She has little time to paint.
In 1927, she is asked to show her art.
Emily goes to Ottawa. She meets an
important artist at her art show. His
name is Lawren Harris.

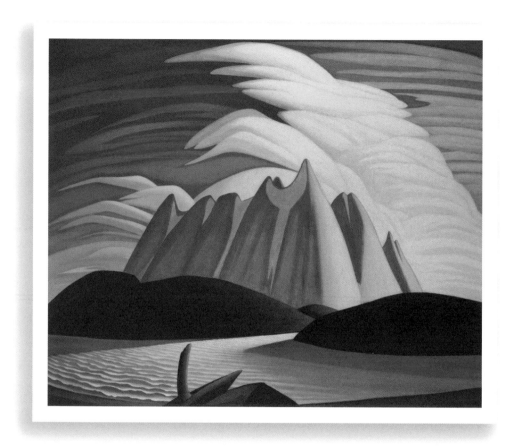

One of Lawren Harris's paintings.

Emily's Mentor

Emily and Lawren become friends. They like each other's art. Lawren is a member of the Group of Seven. Lawren tells Emily she has a lot of talent. Emily now feels good about her art. She is now confident.

The Group of Seven are a group of Canadian landscape painters from the 1920s.

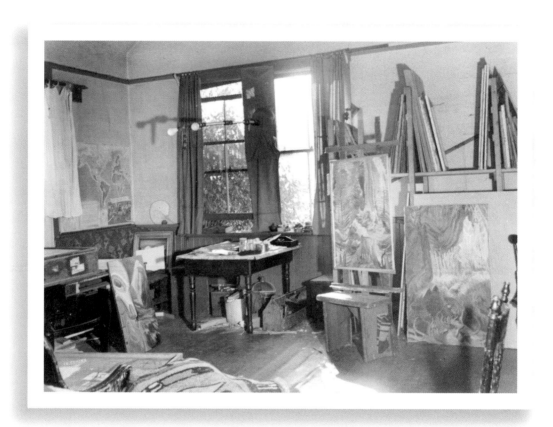

Emily's art studio.

Canada's Treasure

Emily spends more time on her art. She paints the West Coast and loves it. "This is my country. What I want to **express** is here." Some people buy Emily's art. But, Emily never makes a living from her art.

Emily writes many books.

Canada's Treasure

In 1937, Emily has a heart attack.
Painting is hard work. Emily must
slow down. Emily likes to write. She
spends more time writing. Three of
Emily's books are published. She
makes a living as a writer.

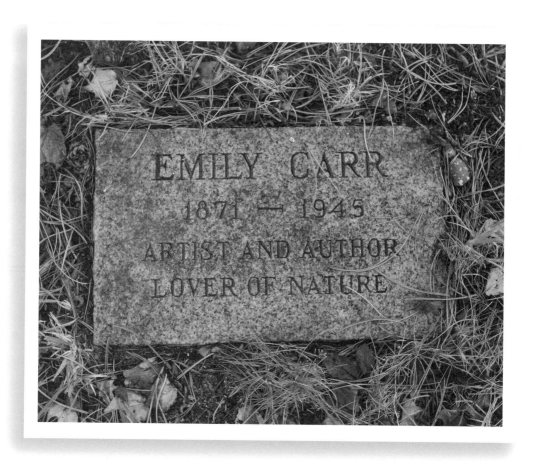

Emily's grave marker.

Canada's Treasure

Emily Carr dies in 1945. After her death, Emily's art becomes famous. Her art is more famous than her writing. Canada's West Coast was Emily's **canvas**. Canada is a richer nation because of Emily's art.

Emily Carr is one of Canada's greatest artists.

Glossary

bid: to make an offer for something.

canvas: a strong cloth on which a painting is made.

express: to make known.

Indian: Indigenous People in Canada who are not Inuit or Métis. The term First Nations has replaced the word Indian.

mentor: an advisor.

unique: being the only one of its kind.

vanish: to disappear.

vow: to make a promise.

Talking About the Book

What did you learn about Emily Carr?

Why did the author call Emily a free spirit?

What hardships did Emily face in her life?

Do you like Emily's paintings?
Why or why not?

Why do you think it took so long for people
to appreciate Emily Carr's paintings?

Picture Credits

Front cover photos: (center photo): © Image D-06009 courtesy of Royal BC Museum, BC Archives; (small photo): © Western Forest, c.1931 (oil on canvas) by Emily Carr (1871-1945) Art Gallery of Ontario, Toronto, Canada/ The Bridgeman Art Library. **Contents page (top right):** © Emily Carr, British Columbia Indian Village, 1928-1930, oil on canvas, Collection of the Vancouver Art Gallery, Emily Carr Trust, VAG 42.3.24; **(bottom left):** © Image G-00414 courtesy of Royal BC Museum, BC Archives; **(bottom right):** © Image F-07885 courtesy of Royal BC Museum, BC Archives. **Page 4:** © Corbis/Andreas Gebert. **Page 6:** © Pat Campbell. **Page 7:** © Image A-09183 courtesy of Royal BC Museum, BC Archives. **Page 8:** © Andreas (Andy) N Korsos, Professional Cartographer, Arcturus Consulting. **Page 9:** © Image H-03313 courtesy of Royal BC Museum, BC Archives. **Page 10:** © Renne Benoit. **Page 12:** © Image R-02037 courtesy of Royal BC Museum, BC Archives. **Page 14:** © Surge of Spring by Emily Carr (1871-1945) Private Collection/Photo © Christie's Images/ The Bridgeman Art Library. **Page 16:** © Image G-05003 courtesy of Royal BC Museum, BC Archives. **Page 18:** © Image I-68874 courtesy of Royal BC Museum, BC Archives. **Page 20:** © Emily Carr, British Columbia Indian Village, 1928-1930, oil on canvas, Collection of the Vancouver Art Gallery, Emily Carr Trust, VAG 42.3.24. **Page 22:** © Image F-07756 courtesy of Royal BC Museum, BC Archives. **Page 24:** © Image F-00254 courtesy of Royal BC Museum, BC Archives. **Page 26:** © Western Forest, c.1931 (oil on canvas) by Emily Carr (1871-1945) Art Gallery of Ontario, Toronto, Canada/ The Bridgeman Art Library. **Page 28:** © Image F-07886 courtesy of Royal BC Museum, BC Archives. **Page 30:** © Image C-05229 courtesy of Royal BC Museum, BC Archives. **Page 31:** © Emily Carr, Not Titled, 1924-1930, clay, paint, Collection of the Vancouver Art Gallery, Bequest of Alice Carr, VAG 51.27.11 **Page 32:** © Image G-00414 courtesy of Royal BC Museum, BC Archives. **Page 34:** © Image I-61505 courtesy of Royal BC Museum, BC Archives. **Page 36:** © Image I-51570 courtesy of Royal BC Museum, BC Archives. **Page 38:** © Lake and Mountains, 1928 (oil on canvas) by Lawren Stewart Harris (1885-1970) Art Gallery of Ontario, Toronto, Canada/ The Bridgeman Art Library Nationality / copyright status: Canadian / in copyright until 2041. **Page 40:** © Image E-01423 courtesy of Royal BC Museum, BC Archives. **Page 44:** © CP/Don Denton.